Dr

MW01061409

LEARNING TO SEE

If you've ever wanted to learn
to draw, or to draw better,
the Learning to See series offers
a mix of inspiration, encouragement,
and easy-to-complete exercises
that will have you filling the
pages of your sketchbook more
confidently in short order.

Drawing Techniques

Peter Jenny

Princeton Architectural Press · New York

For Livia

Princeton Architectural Press
37 East 7th Street, New York, NY 10003

For a free catalog of books,
call 1-800-722-6657
Visit our website at www.papress.com

Originally published by Verlag Hermann
Schmidt Mainz under the title *Notizen
zur Zeichentechnik* © 1999 Professor
Peter Jenny, ETH Zurich and
© 2001 Verlag Hermann Schmidt Mainz
English edition
© 2012 Princeton Architectural Press
All rights reserved
Printed and bound in China
15 14 13 12 4 3 2 1 First edition

Editor: Nicola Bednarek Brower
Translation: Benjamin Smith
Cover design: Deb Wood
Typesetting: Paul Wagner

Special thanks to:
Bree Anne Apperley, Sara Bader,
Janet Behning, Fannie Bushin, Carina
Cha, Russell Fernandez, Jan Haux, Diane
Levinson, Linda Lee, Jennifer Lippert,
Gina Morrow, John Myers, Katharine
Myers, Margaret Rogalski, Dan Simon,
Andrew Stepanian, Joseph Weston, and
Deb Wood of Princeton Architectural Press
—Kevin C. Lippert, publisher

Image credits:
Introduction: Urs Lüthi, *Mutter mit Kind*
 (mother with child)
Exercise 15: Image taken from Egerton,
 Judy, and Dudley Snelgrove. *British
 Sporting and Animal Drawings c. 1500–
 1850. Sport in Art and Books: The Paul
 Mellon Collection.* London: Tate Gallery
 for the Yale Center for British Art, 1978.
Exercise 16: Image taken from
 Metzger, Heinz-Klaus, and Rainer Riehn.
 John Cage. Musik-Konzepte. München:
 Edition Text + Kritik, 1990.
Exercise 18: Image taken from Aicher, Otl,
 and Martin Krampen. *Zeichensysteme
 der visuellen Kommunikation: Handbuch
 für Designer, Architekten, Planer,
 Organisatoren.* Stuttgart: Koch, 1977.

Library of Congress
Cataloging-in-Publication Data
Jenny, Peter, 1942-
[Notizen zur Zeichentechnik. English]
Drawing techniques / Peter Jenny. —
1st ed.
 p. cm. — (Learning to see)
Originally published: Notizen zur
Zeichentechnik. Zurich : ETH, 1999 and
Mainz : Verlag Hermann Schmidt, 2001.
ISBN 978-1-61689-054-4 (alk. paper)
1. Drawing—Technique. I. Title.
NC730.J4613 2012
741.2—dc23
 2011040026

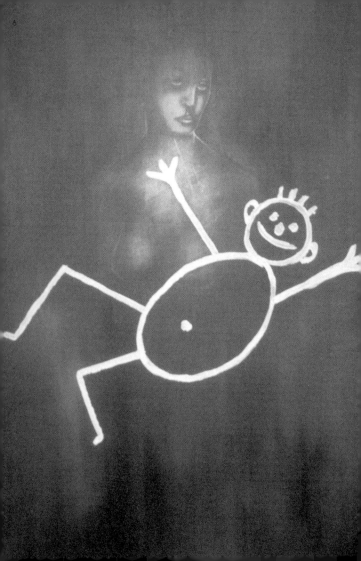

Introduction

In search of lost traces

Who doesn't think back with fondness to the colorful drawings of childhood? They were made with great love, intended, for the most part, for adult relatives. Who didn't want grandmother's warm praise? Whose colored-marker art didn't, at least once, find its way into a picture frame (or on the refrigerator)? We were all once children, but as we became teenagers and entered adulthood, our system of values changed, and we no longer treasured the naïveté of our childhood artwork. Thought processes started to crowd out drawing, and the language of

childhood was left behind. Art class at school couldn't help this—the world of academia values drawing more as an artistic discipline than as a language, and artistic subjects are often seen as pastime activities.

For myself

Those who want to learn not just for practical purposes but to enrich their lives follow the path of self-help. They replace the word *teach* in their vocabulary with the word *discover*. This book's playful activities, coupled with instructions that are more suggestions than commands, aim at easing this process of self-help and encourage you to rediscover the language of drawing.

The lines are inside of us

When we take the direct path to a goal, we generally assume that it is the best one because it is the shortest. However, things are different in the context of drawing. Those who take the

direct path limit their ways of thinking about and creating images. But discovering the language of images is precisely what you should strive to do, not by blindly "copying" the individual drawing activities in this book but by using them to motivate you to expand and combine them as you see fit.

Learn from what we do anyway

Talking, eating, sleeping, communicating, playing—who, except for a few artists and children, would include drawing in this list of daily activities? Yet drawing is essential, even for nonartists and adults. The list above (including drawing) shows that there is no risk of expression becoming standardized, as everyone has his or her own way of doing these things. When talking of drawing, we need to replace the idea of doing something the "right" or "wrong" way with the concept of experimentation. This is the lesson that children teach us—there is no right or wrong way to draw. Most adults assume that

there are established rules in drawing and that they just don't know what these guidelines are. Artists know such rules, but they also know that they exist so that they may be broken. Artists defy these rules in order to find new forms through drawing and to achieve a new way of seeing. Each rule leads us to a set of characteristics that we can examine and experiment with. The following exercises are thus not directives but aids to discovery within the process of drawing— a process that constantly re-creates itself.

The known is the unknown

We know that we see through our sense of vision, but we don't perceive only with our eyes, we also "see" with our ears, our fingers, our nose, and our tongue. All of our senses inform how and what we draw. For instance, when we say that a certain drawing is beautiful, we also think of good or bad "taste." We associate drawings with touch and find our own rhythm in them. While the eyes may be the antenna that leads to

the other senses, every other sense is also able
to take on the role of the antenna. In the end,
your drawings should be as you like them to be—
the only truth is that perception is made up of
the interplay of our senses.

From helplessness to cooperation

A successful drawing is never the result of
the expression of a single sense—it emerges
when one is able to supplement what is missing
using another sense. (The senses are social:
should one fail, the others will come to its aid.)
In drawing, the word *right* is thus a synonym for
meaningful. These observations seem to refer
to a withdrawal into the corporal—to simply rely
on one's senses. By itself that would be too little,
however. Drawing also means opening up by
communicating something.

The pretense of art

Adults automatically think of drawing and sketch-
ing as artistic practices. This qualification

is not surprising, but it doesn't acknowledge the act of perception, which always involves multiple senses. This denial minimizes the possible range of expression. Here a certain hierarchy creeps in: the belief that drawings are always a preparatory step for something more important, something more complete. This hierarchy is also evident in the presumption that the medium belongs to artists alone. The realization that drawing is not only a craft but also an intellectual discipline shows how misplaced this assumption would be.

People who draw…

People who draw more consciously evaluate what they perceive by engaging in visual thinking. Those who draw use not only their eyes but also their other senses in order to "see" something. And those who draw create a void between the lines, which opens up space for other thoughts. Who wouldn't want to be able to do this? All you need is some paper and

a pencil to make lines that sway, swing, inter-twine, delimit, and that spark ideas. Lines, contours, and shading help us complement what is in front of us and create a reality that doesn't really exist—that doesn't aim to look exactly like something—but comes from another motivation: to create something that didn't exist before.

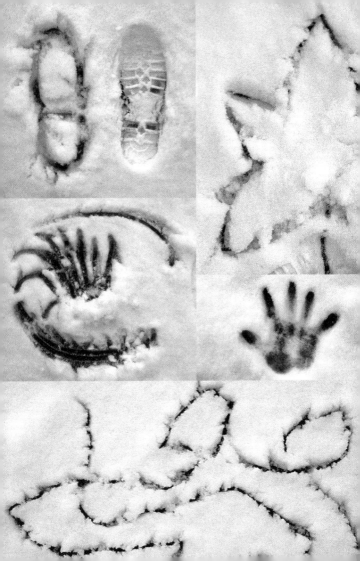

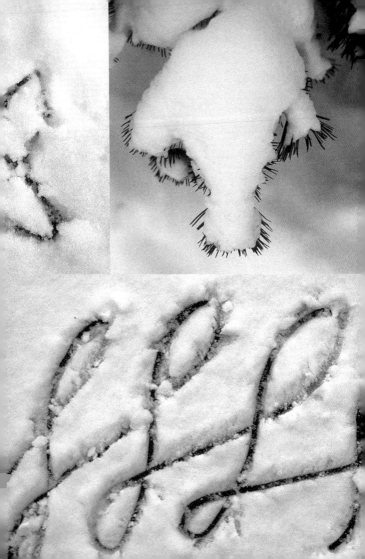

1

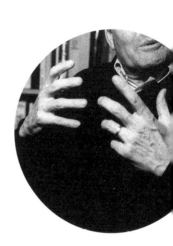

Gesticulate

We all gesticulate with our hands as we speak.
Explaining, illustrating, supporting, and
emphasizing are just a few of the tasks that we
communicate—at least partly—through
gestures. "Drawing in the air" offers us an
opportunity for expression that we can wield
without reservation. Use this process
consciously—speak to someone with gestures.
The gestures can be visualized using a
camera (open aperture) and a flashlight with
a spotlight in a darkened room.

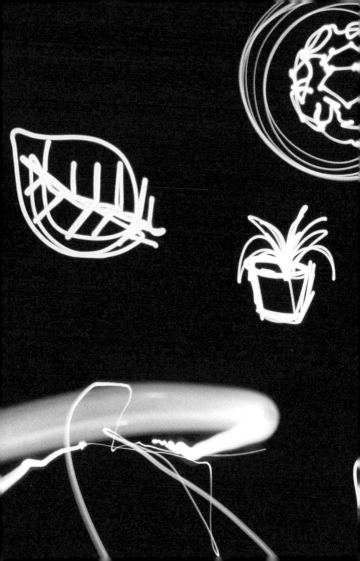

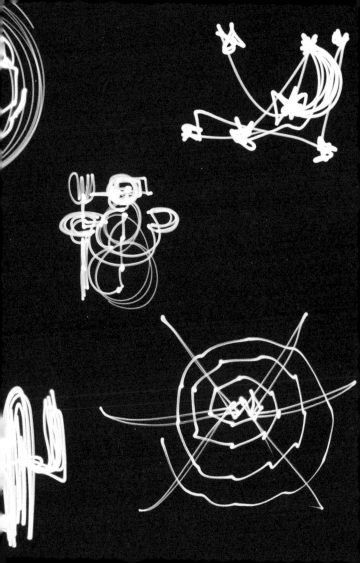

2

40 min.,
one sheet
of
8.5 × 11
paper

Touch

"Seeing" with our hands points to the original
form of grasping something, of understanding.
Close your eyes and run your fingers over an
object for several minutes. Draw it with your eyes
closed. These two exercises can also be done
simultaneously: touch with the left hand and
draw with the right.

3

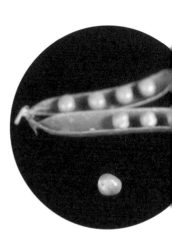

20 min.,
one sheet
of
8.5 × 11
paper

Feel

For this drawing you need a partner who will
draw on your back with his or her index finger.
On a piece of paper, draw the figure you feel
being traced on your body.

4

20 min.,
5.5 × 8.5
paper

Doodle

Doodling, tracing, drawing one ornament after another are all examples of casual drawing. While on the telephone or waiting, we often end up unconsciously doodling. This is something most people do throughout their lives. That means that there is a form of drawing that is never given up. Grab a pen and create some doodles. Discuss them with a partner or friend.

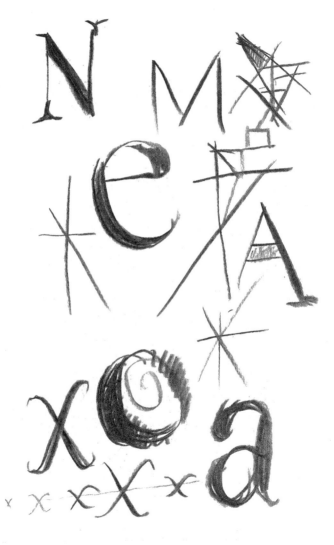

5

Move

When the body is ready to move, joints
loosen and prepare for motion. The extent of
the movements is not important here—what
is essential is the pictorial trace that the action
leaves behind. (See also chapter 7, "Write.")

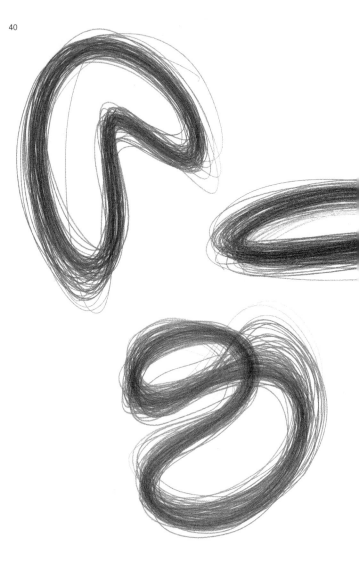

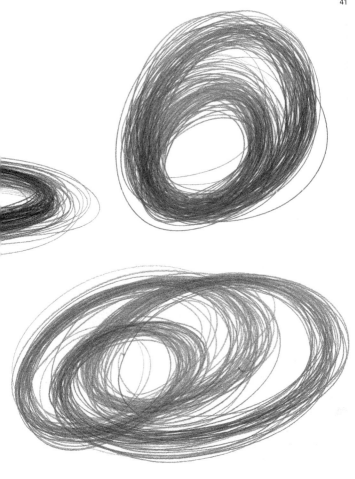

6

20 min.,
one sheet
of
11 × 17
paper

Differentiate

As a rule, forms created through movement display strong curves. Just as diverse as trails, paths, and streets can be, lines can also express a variety of forms. Consider this fact by drawing various curves and contours.

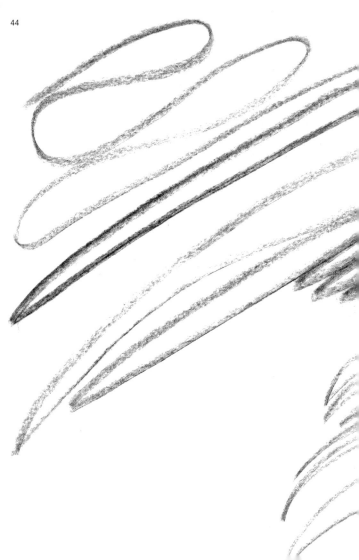

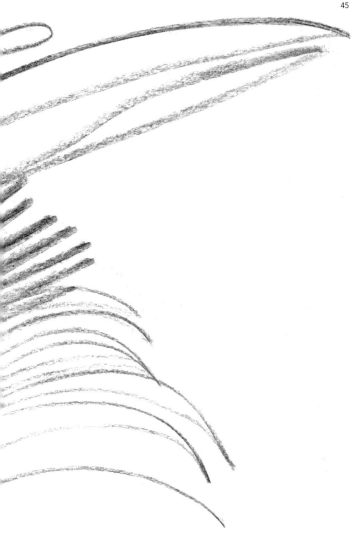

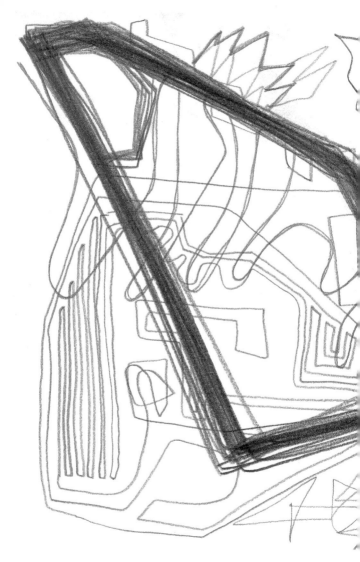

7

Write

Every person has an individual style of
handwriting that can be used not only to write
words but also to draw personal sketches.
In your own handwriting, try to form letters
into picturelike shapes. The drawings will
still be reminiscent of letters but will also start
to look like images. In the beginning there
was the image, then came pictographs,
and then lettering. We're attempting to retrace
this progression in reverse in our drawings.
Draw, as if writing, picturelike forms.
(See also chapter 5, "Move.")

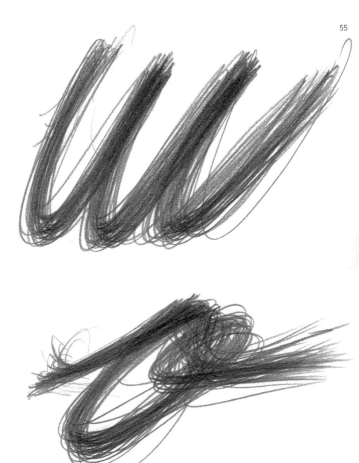

8

30 min.,
one sheet
of
8.5 × 11
paper

Form

When you knead a piece of dough, your hands
search for forms. These forms are a result of
the material you are handling and of your
creative will. Lines can also be viewed as a type
of material, and depending on how you start,
trace, and layer them, you will encounter
different forms, topographies, and surfaces.

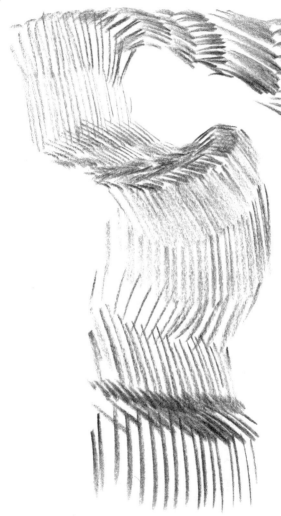

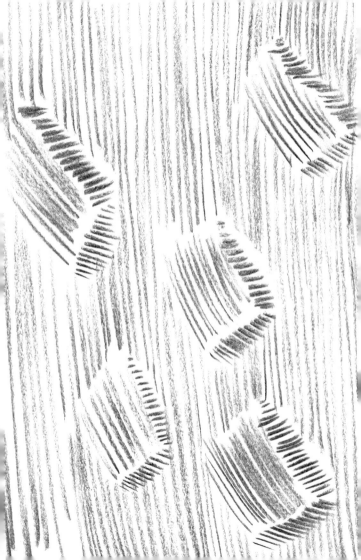

9

40 min.,
one sheet
of
8.5 × 11
paper

Model

Instead of a potter's wheel and a lump of clay,
use a soft pencil and the surface of the paper
to model an object. The method of drawing
should influence the content. Try to make your
choice so that the object's form and the drawing
technique complement each other.

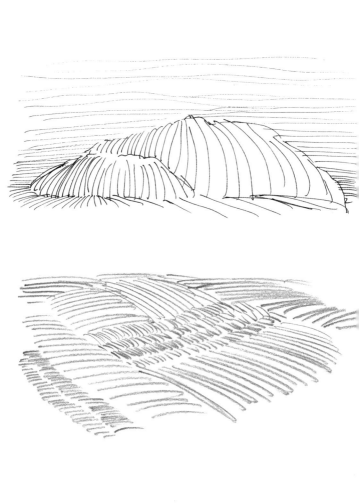

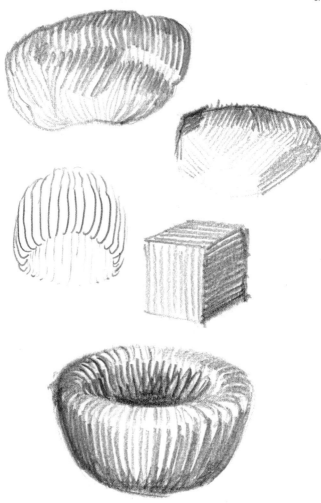

10

Materialize

Many people abandon drawing when their
work fails to match their self-imposed
expectation of realism. For most this happens
between the ages of eight and twelve. (The
exceptions are those who consider themselves
talented.) Start the process again; try to accept
"mistakes" instead of giving up completely.

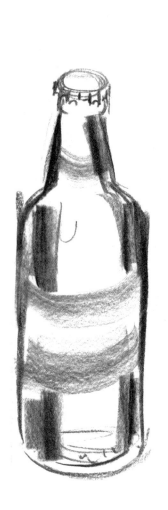
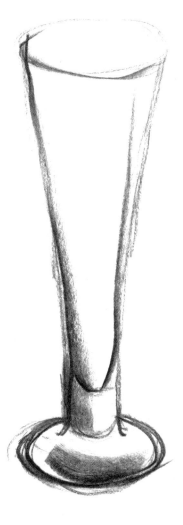

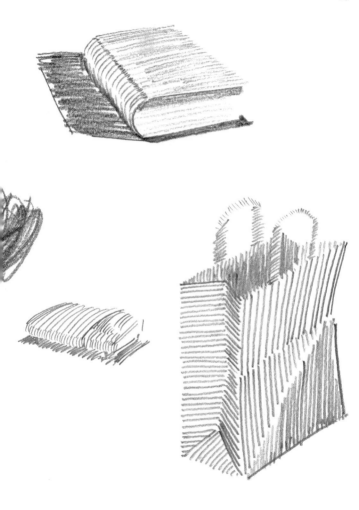

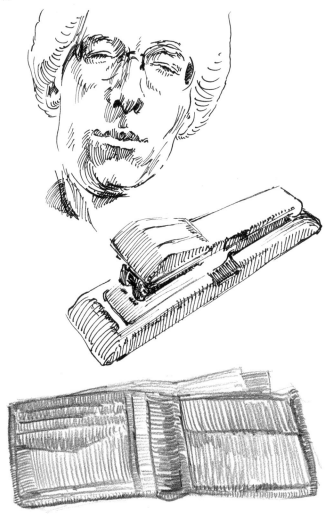

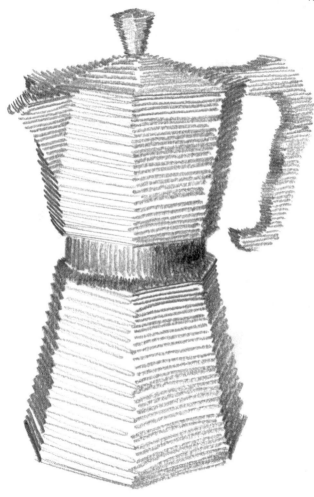

11

40 min.,
one sheet
of
8.5 × 11
paper

Trace

Drawing two-dimensional objects is less
daunting than complicated three-dimensional
subjects. Subjects that are flatter (leaves,
scissors, spoons, and so on) can be put to paper
more easily. Every characteristic form has
an exterior outline—trace these first before
tackling interior shapes.

12

Deconstruct

Most objects are made of fundamental
forms that can be broken down into geometric
shapes. Cubes, spheres, cylinders, pyramids,
etc., can be used as volumetric borders to draw
many objects. Start with the geometric shape
and sketch the subject of your drawing into
these outlines.

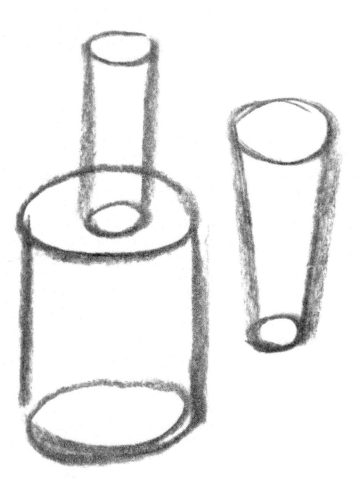

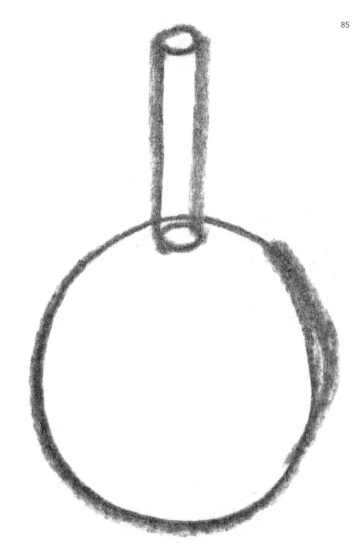

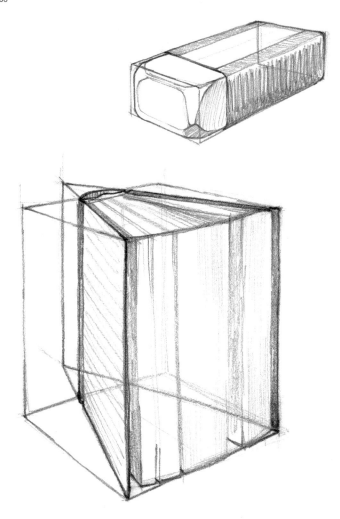

13

50 min.,
one sheet
of
8.5 × 11
paper

Abstract

Backlighting, which may be familiar to you from photography, involves lighting the subject from behind, darkening it and greatly simplifying its appearance—similar to a silhouette. This shadow image illustrates the idea of abstraction. Distill an object down to the most essential pictorial information.

14

50 min.,
one sheet
of
8.5 × 11
paper

Fragment

We can only ever see a fraction of everything that surrounds us. The brain fills in the rest of the details. Make use of ruins, fragments, pieces, and found objects for this exercise—let them inspire you to draw. Destroy an object that you won't miss. Draw a small collection of broken pieces of various objects. Choose simple forms.

15

Imagine

The idea for a drawing and the drawing itself never coincide. The inevitable separation between your imagination and the physical drawing lead to the question, What do the things really look like? Draw from imagination, and if the drawings fail in your opinion, articulate what you see as their shortcomings or discrepancies (through words and sketches).

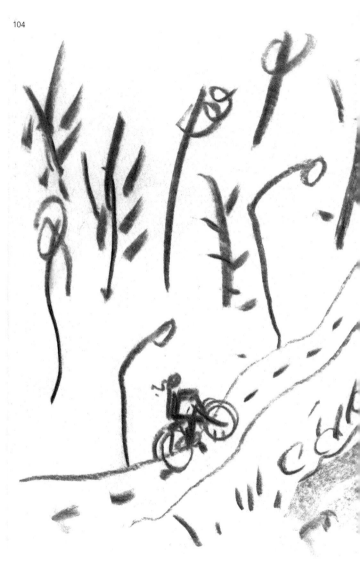

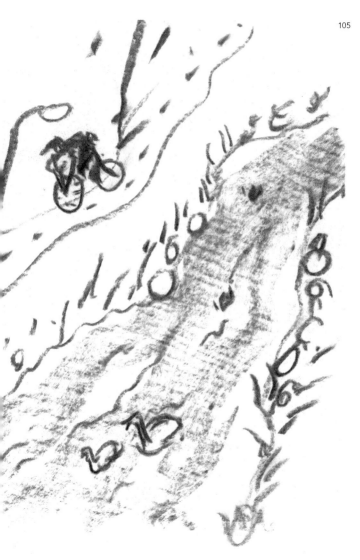

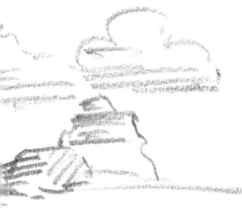

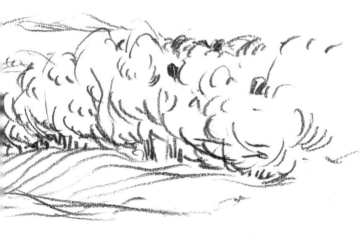

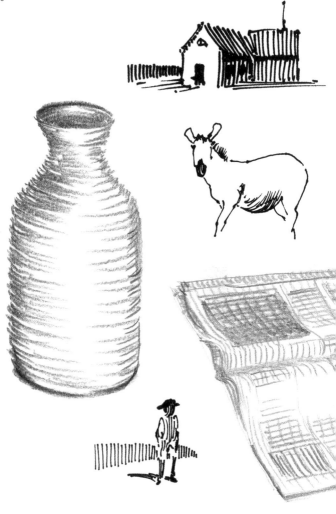

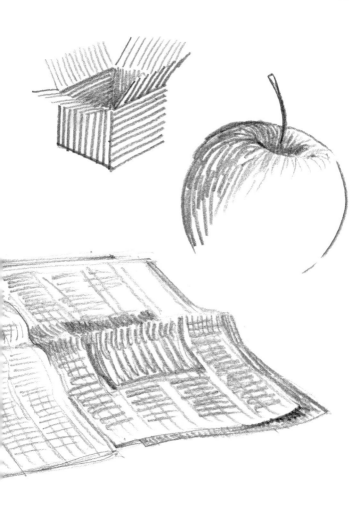

16

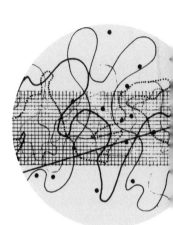

30 min.,
one large
sheet of
drawing
paper

Listen

A drawing is a drawing; a sound is a sound.
The transformation of one into the other is
only possible when deviations from the modes
of expression specific to each form or media
are permitted. Find an acoustic example
and transform it into a drawing. Whether the
transformation is visually successful or new
inspiration is gained is unimportant. What is
important is only the rhythm of the drawing.

17

Smear

Smearing awakens memories of childhood.
The eyes and the brain work together perfectly
within the figurative constraints created
by perception. (Figuration is not just a direct
expression of nature. The figure is also the
form that the eye tries to uncover.)

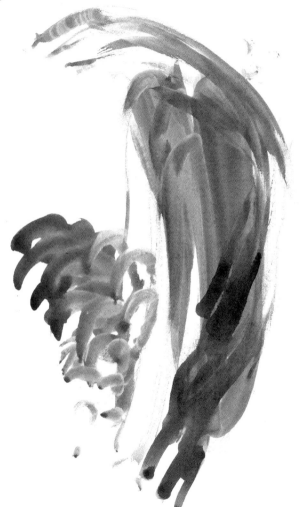

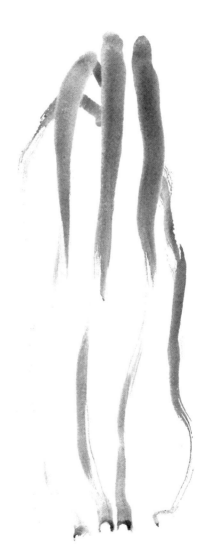

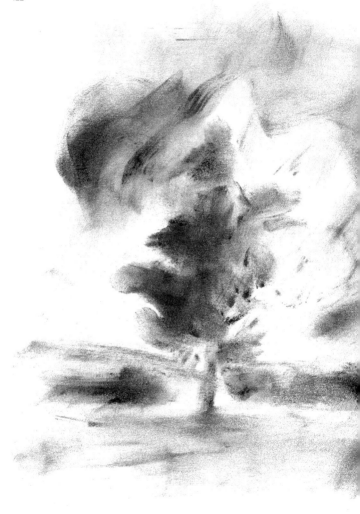

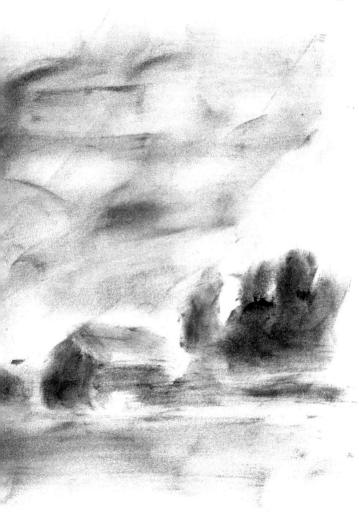

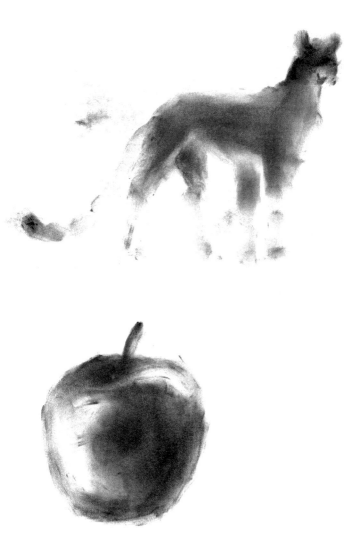

18

woch Donne.

9°
2°

14°
5°

m ■ Temperat

www.m

Symbolize

The world is full of visual symbols, pictograms,
and hieroglyphs. Manuals, instruction docu-
ments, packaging materials, brochures, and
information boards all use visual communication
that would be impossible without these images.
Choose three such motifs and use them as the
basis for a simple story told in images. Series,
overlays, and changes in scale are all formal
approaches you can experiment with regardless
of the content you choose.

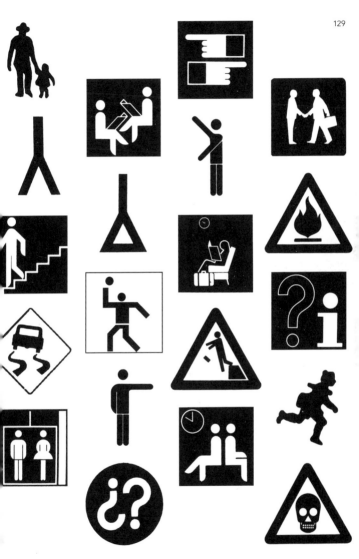

19

40 min.,
one sheet
of
8.5 × 11
paper

Imply

Drawings reveal their meaning both during
the process of making and during viewing.
Suggestions awaken memories and provoke the
imagination. Sketch out some random symbols,
forms, curls, spots, and other fragments in
various configurations. Think of a few possible
interpretations for your sketches and render
some of them more clearly.

20

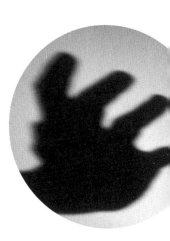

Distort

Our shadows are our constant companions throughout our lives. Depending on the position of the light source (low or high), shadows distort to differing degrees. Multiple light sources allow for a larger range of distortions and open up greater possibilities for playing with image and form. Sketch shadows with various shades of gray and types of distortions.

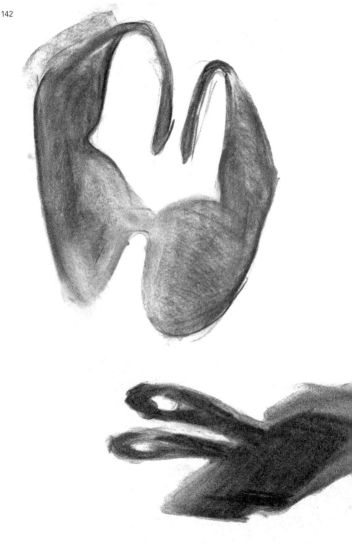

21

Conceal

Tracing and copying are not skills valued in drawing classes, but in this exercise they can show that hierarchies are always worth reconsidering. Trace objects you find on photographs or copies. Superimpose these drawings until the individual images are difficult to identify. Within the density of the layers, the attentive eye may discover unexpected elements that can inspire other drawings.

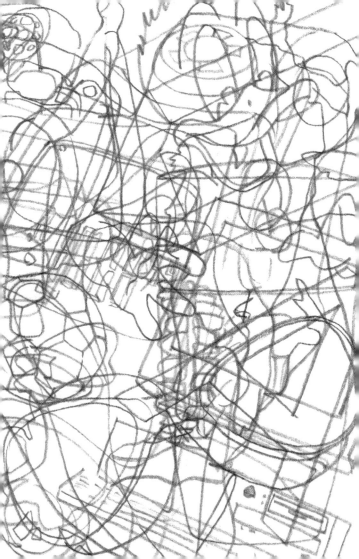

22

40 min.,
one sheet
of
8.5 × 11
paper

Exaggerate

We sometimes exaggerate in our conversations
(or in other parts of our lives). Exaggeration
abandons certain details and nuances while also
highlighting the need for greater preciseness.
In this exercise try to transfer this idea of
exaggeration to drawing by covering three-
dimensional objects with malleable materials
(clay, dough, cloth, wet paper, etc.). The original
outline will remain but the general form will
be simplified. Sketch these objects from
various angles.

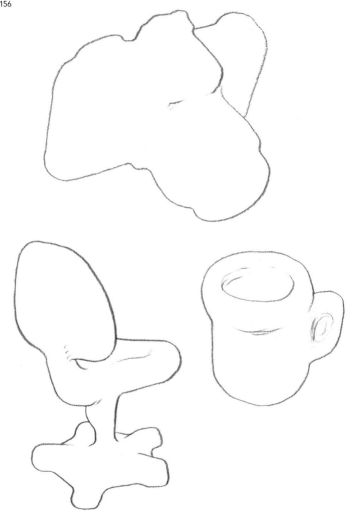

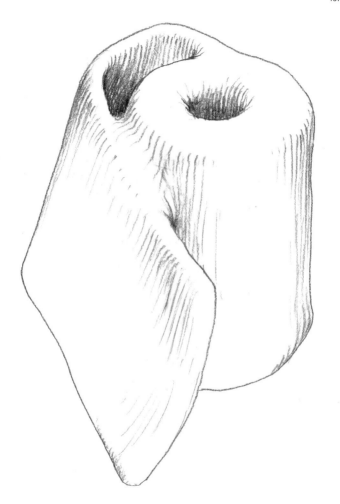

Notes

Review the following notes after creating your first drawings. When repeating the exercises, keep these goals and questions in mind.

1 Gesticulate

Goal: The perception of spatial relationships within drawings. Drawing without differentiating between the right and left hand.

Question: What happens when you draw with both hands simultaneously on a sheet of paper?

2 Touch

Goal: To link the senses of touch and sight.
A concentration exercise.

Questions: What do the drawings that you make with eyes closed versus those you create with eyes open look like? (The target times for the two versions should be different: short when eyes closed, longer with eyes open.) How does your drawing develop differently when you aren't familiar with the object you are drawing? (Somebody hands you an object.)

3 Feel

Goal: From skin to paper. To become aware of the differences in transmission of an object.

Questions: What happens when an object is drawn on your back by a person who only knows the object from another person drawing it on his or her back? How does a sentence change as it is passed from one ear to the next (like in a game of telephone)?

4 Doodle

Goal: To contemplate a form of drawing that is usually done absentmindedly or automatically.

Questions: What shapes develop when you start from randomly generated marks? What do the drawings look like when more than one person—in succession—contributes to a doodle?

5 ● Move

Goal: To become conscious of various types of movement (fingers, hands, arms, the body as a whole).

Questions: How do the drawn forms differ when the size of the paper is chosen based on the radius of the movement? What do the marks look like when the drawing surface is laid down flat as opposed to those drawn when it is placed upright?

6 ● Differentiate

Goal: To create a small inventory of various types of lines.

Question: What kinds of lines develop when you speak certain syllables (hard, soft, etc.) while drawing?

7 ● Write

Goal: To redefine familiar written letters and words by making them illegible.

Questions: What is visual poetry? What possibilities of form arise when you enlarge and distort textual excerpts?

8 ⬤ Form

Goal: To manipulate lines to create malleable shapes.

Question: What do skinny, fat, rough, bulging, and constricting lines look like?

9 ⬤ Model

Goal: To explore the idea of malleability (compare with 8, "Form").

Question: Can these drawn forms be easily identified?

10 ⬤ Materialize

Goal: To investigate how to accurately draw an object.

Question: Do the drawings give us any idea of how the object was constructed (its composition) or how it is used (function)?

11 ⬤ Trace

Goal: To simplify the content of an image.

Question: What objects are suitable for a quick sketch of their outline?

12 ● Deconstruct

Goal: To break the whole down into simple, constituent shapes.

Question: Which objects have the general shape of a pyramid?

13 ● Abstract

Goal: To use abstraction to simplify forms.

Questions: What other methods of abstraction are there? How can you make an abstraction from a photograph? By placing transparent paper over the object in the photograph and drawing its outline?

14 ● Fragment

Goal: To create a "collection" of small, personal fragments.

Questions: If you photocopy three-dimensional fragments, how is the representation of the subjects on the copies different from that on your drawings? What image captions can you think up to alter the meaning of the fragments?

15 ⬤ Imagine

Goal: To provide verbal expression for drawings.

Questions: What can I draw? And how can I explain what I've drawn? How can I use written information to clarify the drawing? How can I alter the perception of an image with supplementary information?

16 ⬤ Listen

Goal: To depict pictorially the rhythm of sounds.

Question: What sounds do people hear when viewing your drawings? (Perhaps even record the tones you are drawing and compare them to other people's interpretations of your drawings.)

17 ⬤ Smear

Goal: To transform the perception of an activity typically viewed negatively into a positive one.

Questions: What can I draw with nothing more than my bare fingers and some graphite powder? What other images can I uncover when I view the drawing from any of its four sides?

18 Symbolize

Goal: To use existing pictograms and symbols in a new way.

Questions: What story can you tell with just three symbols? Is the story understandable to another person?

19 Imply

Goal: To seek out forms.

Question: What suggestions do others see in your sketches? (Make copies of your drawings and distribute them.)

20 Distort

Goal: To explore techniques that exclude the possibility of "mistakes."

Question: How else can I distort the shadow in order to create surprising images?

21 ⬤ Conceal

Goal: To discover unexpected forms in dense viewing conditions. To uncover new ways of combining forms.

Questions: When can drawings (of individual forms) be placed on top of one another and still remain recognizable? Which superimpositions result in new relationships between the layers (trace them again in different combinations)?

22 ⬤ Exaggerate

Goal: To use an unexpected process to distort an object.

Question: What other common techniques can be used to assist in drawing?

Final Remarks

Handle your drawings as works of art:
store them in a portfolio, frame them,
hang them on the wall, and so on. Once you
have completed all twenty-two exercises,
use this book as a notebook or sketchbook:
draw over the printed images as you desire.
Leave some fragments of the printed images
as they are, but take the opportunity to
create a new book. This can be seen as the
final exercise.